LANCASTER

HISTORY TOUR

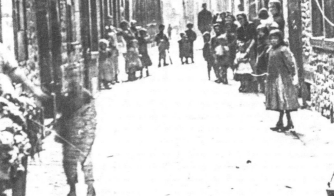

First published 2015

Amberley Publishing
The Hill, Stroud,
Gloucestershire, GL5 4EP
www.amberley-books.com

Copyright © Jon Sparks, 2015

The right of Jon Sparks to be
identified as the Author of this work
has been asserted in accordance with
the Copyrights, Designs and Patents
Act 1988.

ISBN 978 1 4456 4854 5 (print)
ISBN 978 1 4456 4855 2 (ebook)

British Library Cataloguing in
Publication Data.
A catalogue record for this book is
available from the British Library.

Typesetting by Amberley Publishing.
Printed in Great Britain.

INTRODUCTION

I wasn't born in Lancaster, and I live a few miles away now, but I'll always call it my hometown – and I'm very glad to do so. It wasn't just a great place to grow up; it also had a lot to do with getting my career as a photographer off the ground. The following pages include the shop where I bought my first camera, as well the venue of my first photographic exhibition, and of course many views and subjects that featured on early greetings cards, in Lancaster Tourism publications and, from 1994, the Lancaster Calendar.

I've since photographed in many parts of the world and have enjoyed and admired cities as diverse as Istanbul, Vancouver, Prague, Oslo and St Petersburg. Among larger cities, I have no hesitation in naming Helsinki as my favourite – but among smaller places, I can't think of many that reward the photographer more than Lancaster. The two hills and the curves of the river create a rare variety of vistas.

Lancaster also has a long and eventful history and a rich variety of architecture. Six Grade I listed buildings is a pretty good score for a place of this size, but there's more to it than a handful of big hitters. From the Customs House to the Borough, there are gems all over the place. However, Lancaster has also lost many treasures. For me, the most striking aspect of my research has emerged not from eighteenth-century engravings or nineteenth-century photographs, but from the most recent material. I've been particularly fascinated by images from the 1970s, when I was at school in the town. Some have wakened dormant memories, but in many I've barely recognised the place.

Any Lancastrian over a certain age will remember the fire that destroyed the Market Hall in 1984. The decision not to rebuild on the same site looks like folly now, with the smaller replacement market closing its doors in 2012. With the recent revival of interest in artisan foods, local crafts and so forth, a 'proper' market ought to be a real draw here, but much of that buzz is confined to the street market that springs up a couple of days a week.

An even bigger folly is the wholesale destruction of acres of housing and employment back in the 1960s and '70s; much of this 'Eastern Corridor' is nothing better than windswept and puddle-strewn car parks even now. At least the threatened (and criminally misnamed) 'Relief' road never materialised, and this area is slowly coming back to life, with some decent looking new apartment blocks south of Nelson Street, and redevelopment is finally on the cards for the Old Brewery. But there's plenty to celebrate too. Those same old photographs show a lot of nondescript and often tatty architecture, and there are some fine examples of development that marries the best of the old with the best of the new, such as the White Cross Mills site and the east side of Dalton Square. St George's Quay probably looks better than at any time in its history, and there's more to come on the freshly cleared site just west of Carlisle Bridge. Most exciting of all, the castle is going to become a public space. The closure of the prison has been 'just around the corner' for as long as I can remember – now it's finally happened. I've already had the real thrill of walking through John O'Gaunt's Gate for the first time.

Lancaster has suffered some tragic losses, but it hasn't had its heart ripped out like many towns I could name. It's still, by and large, a graceful and humane city. It's a place to cherish and many people do. Working on this book has required me to take a fresh look at my hometown, and overall I like what I see.

ACKNOWLEDGEMENTS

Taking the new photographs was the easy part. Tracking down the historic images was far more challenging, especially as I've been determined to respect copyright (it's my lifeblood as a photographer, so I have to respect that of other people).

While many people helped, two special mentions are warranted.

First, Lancaster University archivist Marion McClintock gave up several hours of her time and dug out many fascinating images as well as providing masses of background information.

Second, I'm indebted to Graham Hibbert and Michael Bolton for most of the 1960s–'70s images. Graham's pages on Flickr are a treasure trove for anyone curious or nostalgic about Lancaster during this period, and there's quite a community feeding in comments and other snippets of information.

Others who provided images and/or access are:

Helen Clish, Lancaster University Library

Rose Welshman, Jenny Cornell and Rory Hudson, Lancaster Royal
 Grammar School

John Law

Bruce Grime

Martin Sherlock, Lunesdale CAMRA

Peter Donnelly, King's Own Royal Regiment Museum

Gary Yates, Lancaster Golf Club

Caroline Hull, St Peter's Cathedral

Miriam Ward, Wellcome Images

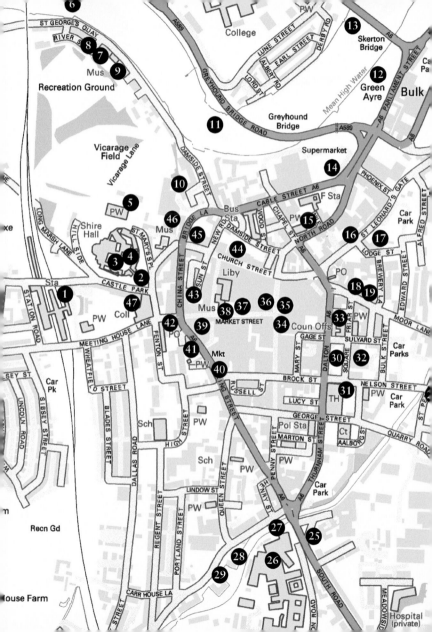

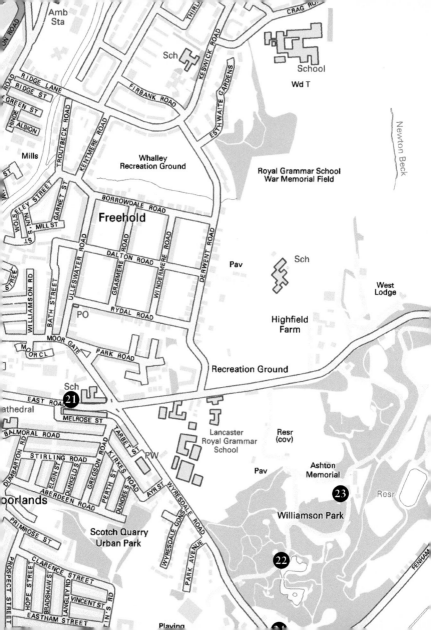

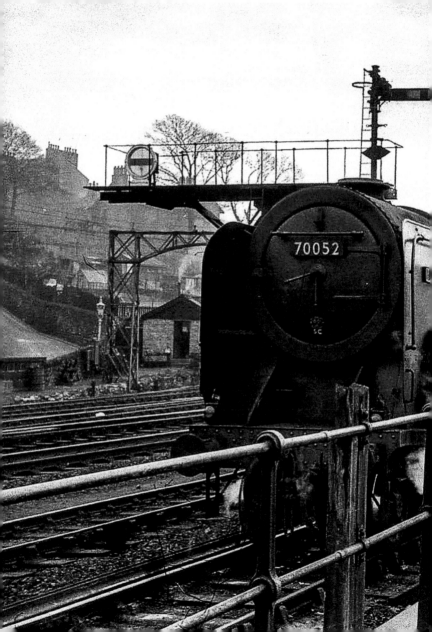

1. LANCASTER STATION

Originally known as Lancaster Castle Station in order to distinguish it from the first Lancaster Station (1840–49), Lancaster station was officially opened on 21 September 1846. Its first service ran into the station on 17 December of the same year.

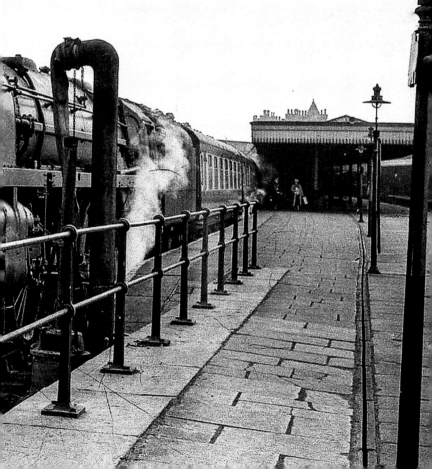

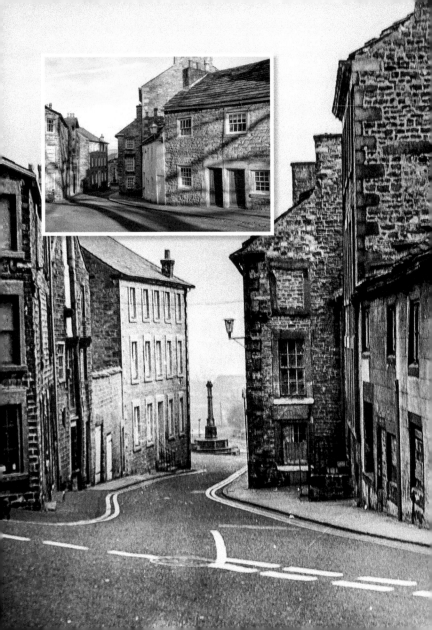

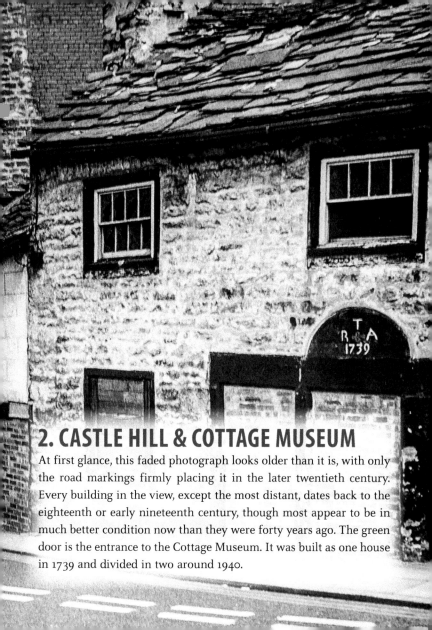

2. CASTLE HILL & COTTAGE MUSEUM

At first glance, this faded photograph looks older than it is, with only the road markings firmly placing it in the later twentieth century. Every building in the view, except the most distant, dates back to the eighteenth or early nineteenth century, though most appear to be in much better condition now than they were forty years ago. The green door is the entrance to the Cottage Museum. It was built as one house in 1739 and divided in two around 1940.

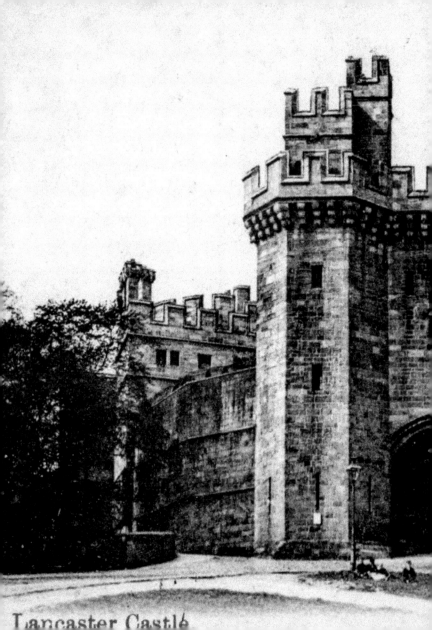

Lancaster Castle

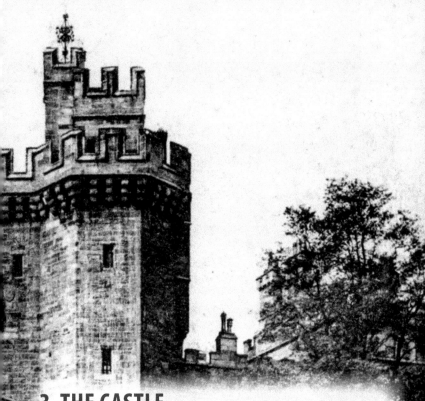

3. THE CASTLE

Though it dominates the town, the castle has also been somewhat detached, as most of it has been used as a prison throughout living memory, with only a small (albeit fascinating) section open to visitors. However, the prison has finally moved out and the Duchy of Lancaster has unveiled plans to open it as a 'mixed-use urban quarter that incorporates a museum, public spaces, events and performance areas, corporate and education facilities and a boutique hotel'. The gates and countryard are already open and there's a café inside.

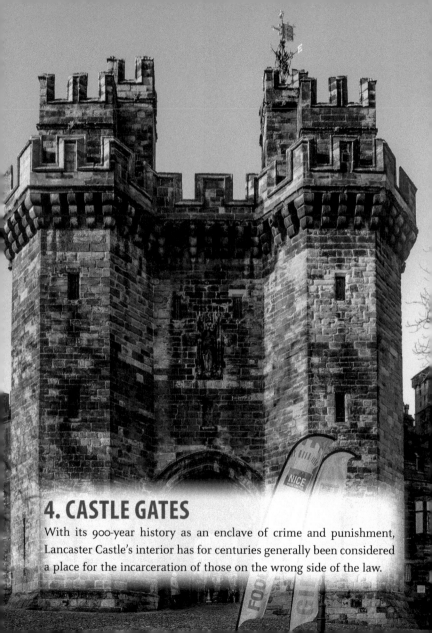

4. CASTLE GATES

With its 900-year history as an enclave of crime and punishment, Lancaster Castle's interior has for centuries generally been considered a place for the incarceration of those on the wrong side of the law.

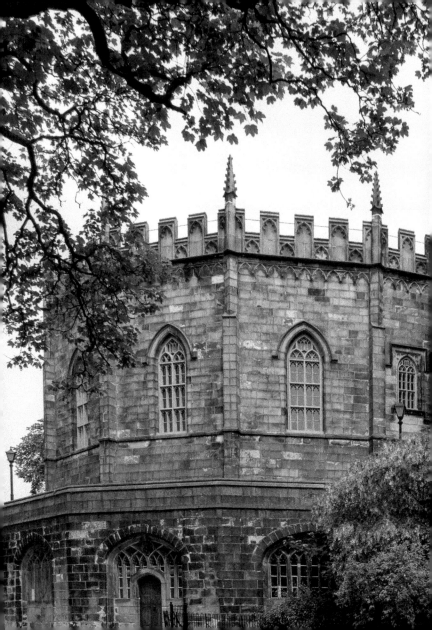

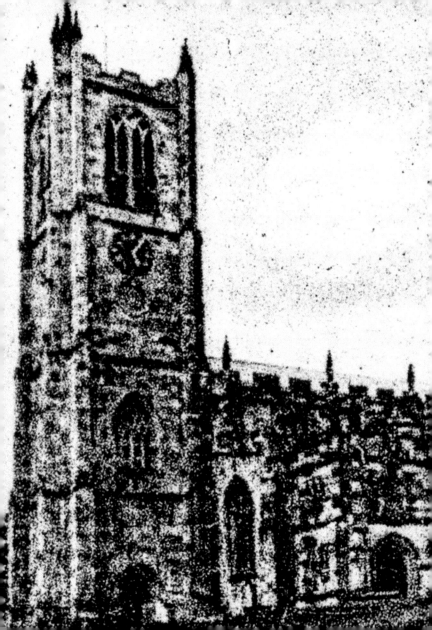

5. PRIORY CHURCH

There was almost certainly a Saxon church on the site, but the oldest identifiable masonry is Norman. A Benedictine priory was founded here in the late eleventh century. The bulk of the present structure, from the late fourteenth and early fifteenth centuries, is a very fine example of the English Perpendicular style. Vicarage Lane is a useful footpath to take, down past the churchyard and on to St George's Quay.

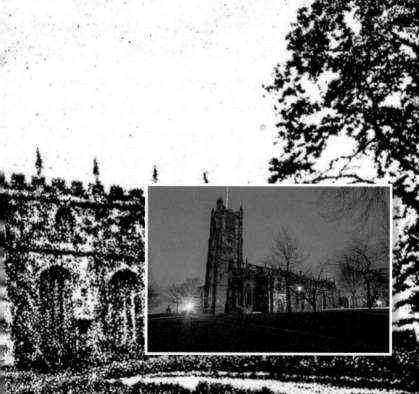

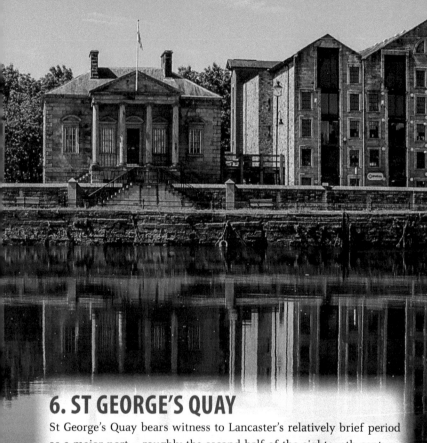

6. ST GEORGE'S QUAY

St George's Quay bears witness to Lancaster's relatively brief period as a major port – roughly the second half of the eighteenth century. As ships grew larger, trade shifted first to Glasson Dock (linked to the canal in 1819) and then to Heysham Harbour. Many original warehouses still stand, now used mainly as housing.

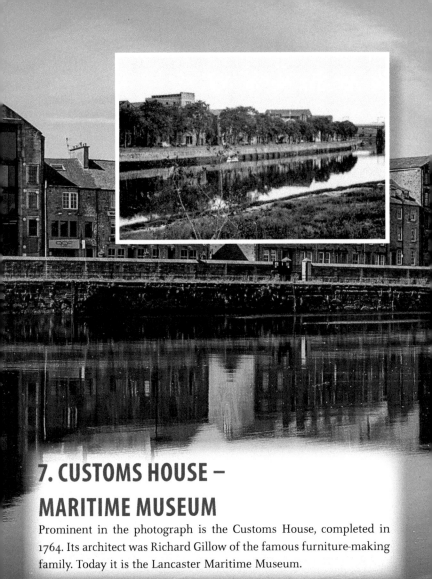

7. CUSTOMS HOUSE – MARITIME MUSEUM

Prominent in the photograph is the Customs House, completed in 1764. Its architect was Richard Gillow of the famous furniture-making family. Today it is the Lancaster Maritime Museum.

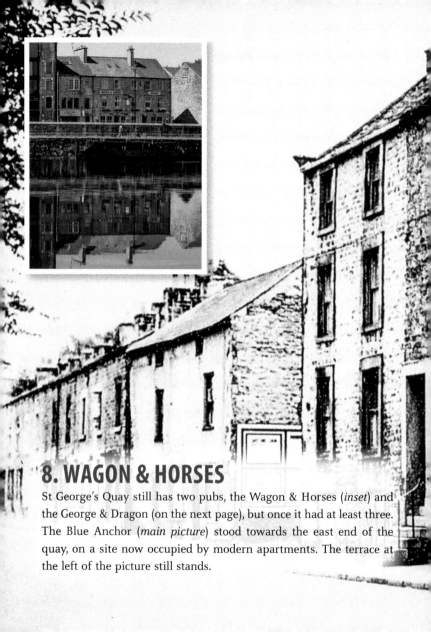

8. WAGON & HORSES

St George's Quay still has two pubs, the Wagon & Horses (*inset*) and the George & Dragon (on the next page), but once it had at least three. The Blue Anchor (*main picture*) stood towards the east end of the quay, on a site now occupied by modern apartments. The terrace at the left of the picture still stands.

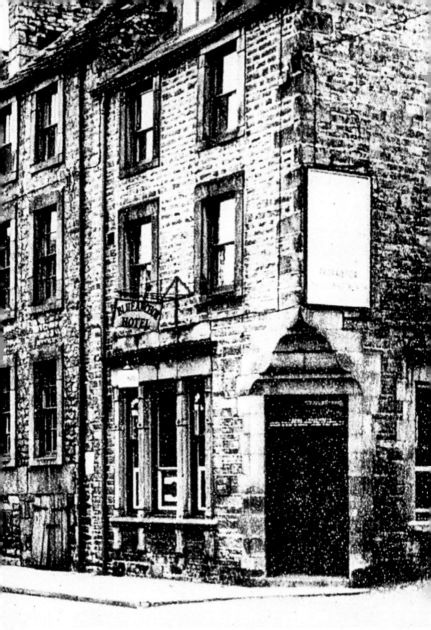

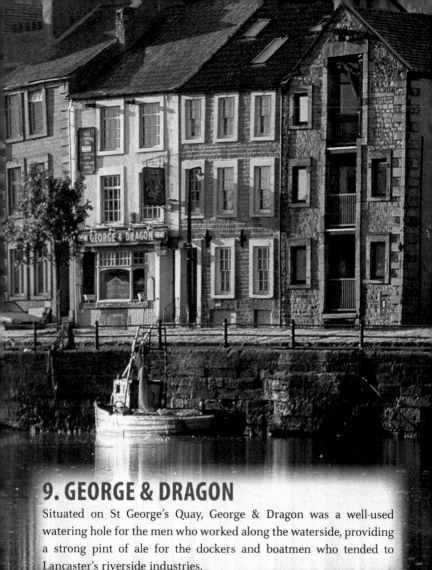

9. GEORGE & DRAGON

Situated on St George's Quay, George & Dragon was a well-used watering hole for the men who worked along the waterside, providing a strong pint of ale for the dockers and boatmen who tended to Lancaster's riverside industries.

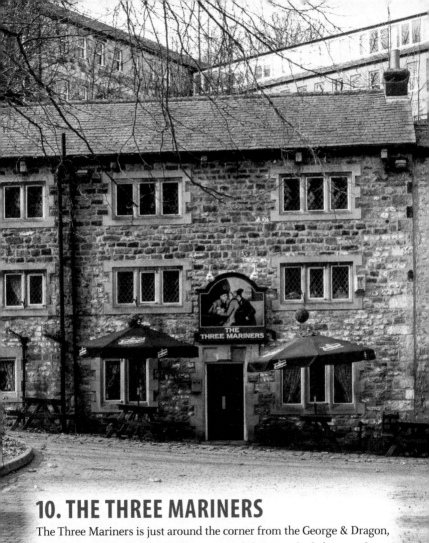

10. THE THREE MARINERS

The Three Mariners is just around the corner from the George & Dragon, and was a regular haunt for the men and their parched throats after a hard day working along the quay. Shifting cargo was thirsty work.

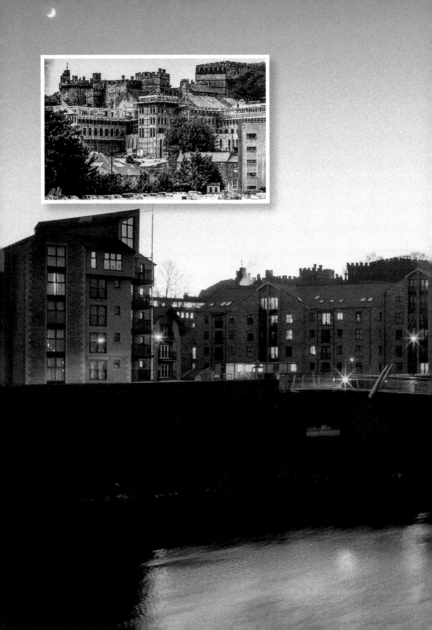

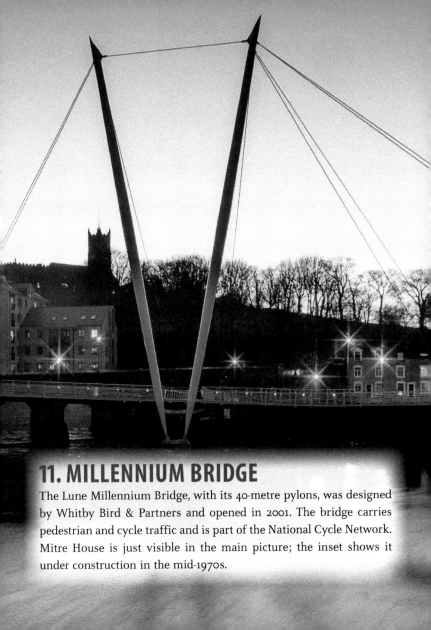

11. MILLENNIUM BRIDGE

The Lune Millennium Bridge, with its 40-metre pylons, was designed by Whitby Bird & Partners and opened in 2001. The bridge carries pedestrian and cycle traffic and is part of the National Cycle Network. Mitre House is just visible in the main picture; the inset shows it under construction in the mid-1970s.

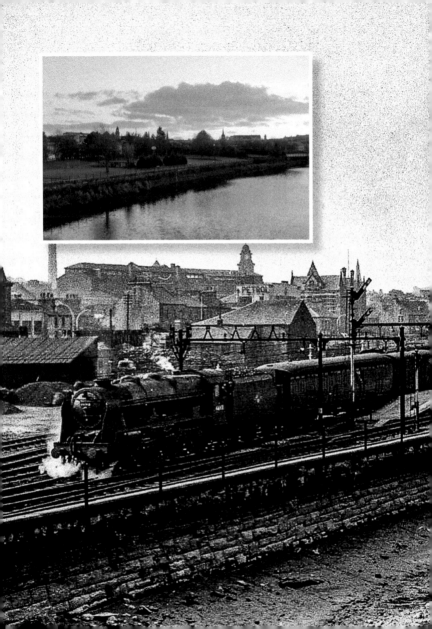

12. SITE OF GREEN AYRE STATION

Green Ayre station was opened in 1848 by the North Western Railway – known as the 'Little North Western' to differentiate it from the London & North Western, which ran the main north–south line. The line, which linked Leeds and Morecambe, was taken over in 1874 by the Midland Railway. There was also a branch, now a cycle path, linking to the main line station, then known as Lancaster Castle (now simply Lancaster). After closure in 1966, Green Ayre station was soon demolished and the site bisected by the new road over Greyhound Bridge.

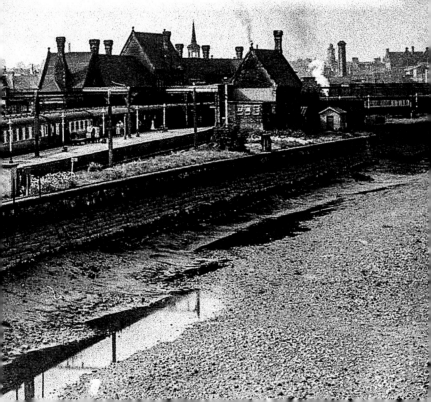

13. SKERTON BRIDGE

Designed by Thomas Harrison and completed in 1788, the bridge was the first large bridge in England with a level roadway. Over 220 years later, it carries a volume and weight of traffic far beyond anything that Harrison could have envisaged. To see this view today you'll need to walk upstream along the cycle path and then find your way through vegetation to the riverbank.

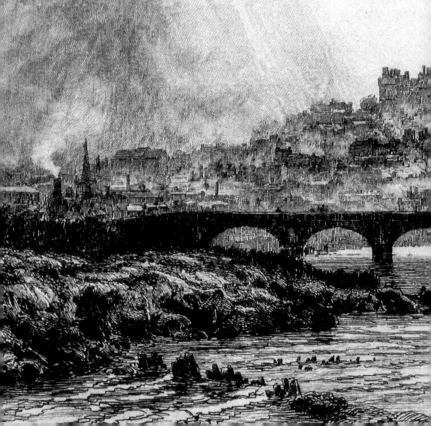

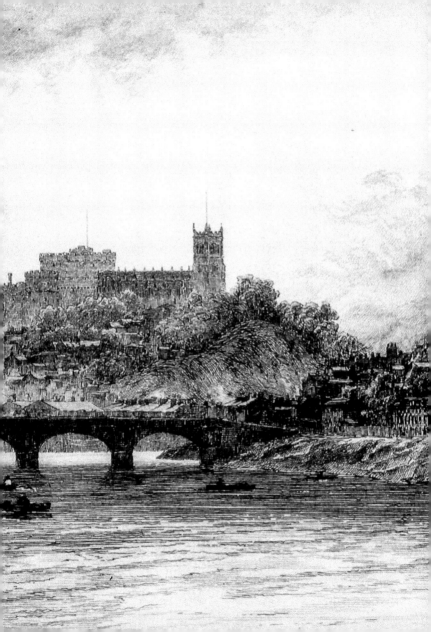

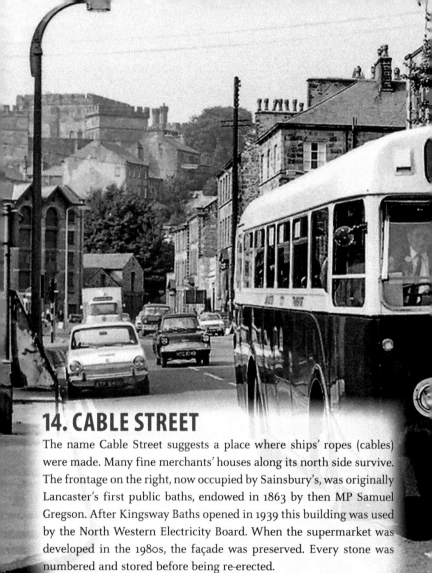

14. CABLE STREET

The name Cable Street suggests a place where ships' ropes (cables) were made. Many fine merchants' houses along its north side survive. The frontage on the right, now occupied by Sainsbury's, was originally Lancaster's first public baths, endowed in 1863 by then MP Samuel Gregson. After Kingsway Baths opened in 1939 this building was used by the North Western Electricity Board. When the supermarket was developed in the 1980s, the façade was preserved. Every stone was numbered and stored before being re-erected.

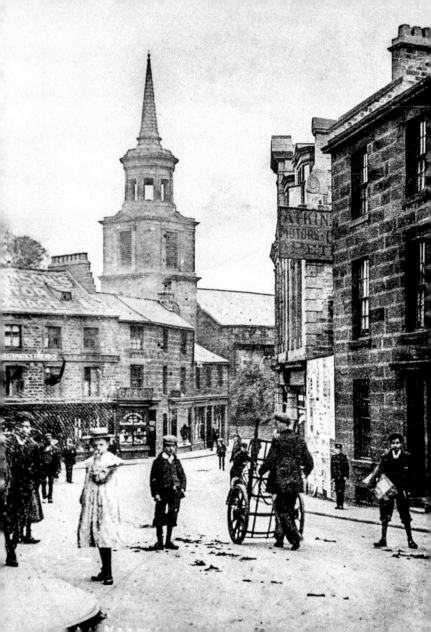

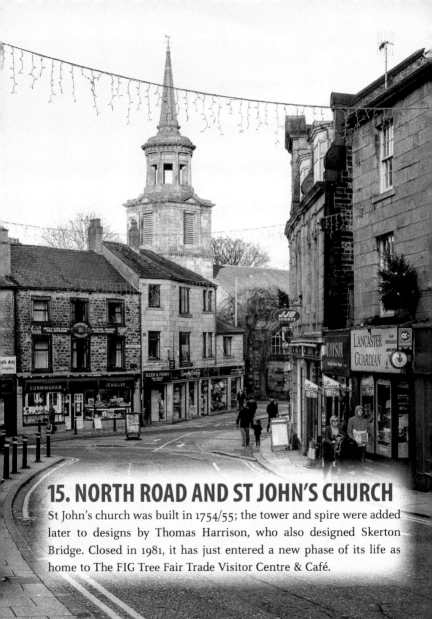

15. NORTH ROAD AND ST JOHN'S CHURCH

St John's church was built in 1754/55; the tower and spire were added later to designs by Thomas Harrison, who also designed Skerton Bridge. Closed in 1981, it has just entered a new phase of its life as home to The FIG Tree Fair Trade Visitor Centre & Café.

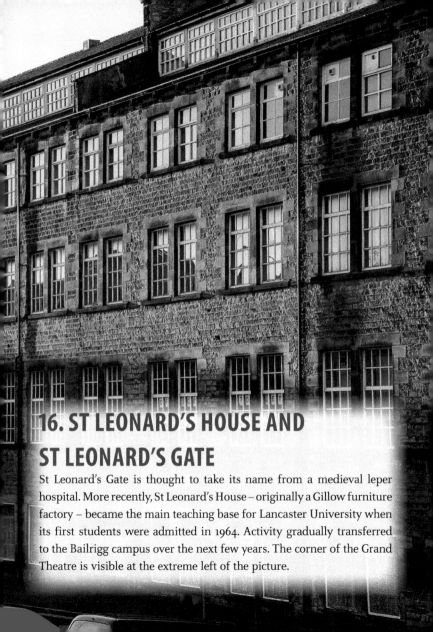

16. ST LEONARD'S HOUSE AND
ST LEONARD'S GATE

St Leonard's Gate is thought to take its name from a medieval leper hospital. More recently, St Leonard's House – originally a Gillow furniture factory – became the main teaching base for Lancaster University when its first students were admitted in 1964. Activity gradually transferred to the Bailrigg campus over the next few years. The corner of the Grand Theatre is visible at the extreme left of the picture.

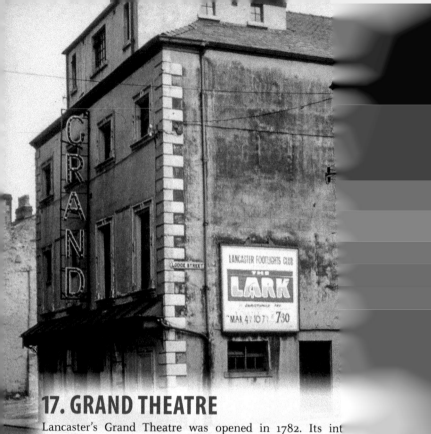

17. GRAND THEATRE

Lancaster's Grand Theatre was opened in 1782. Its int
extensively remodelled in 1897 under the direction of
theatrical architect Frank Matcham. Lancaster Footlights
it in 1951. Unbelievably, they were presented with a co
purchase order in 1959 as the powers that be schemed to
Eastern Relief Road and industrial corridor. Naturally, the
outcry and eventually sense prevailed. Extensive further r
took place from 1980 onwards. Footlights, now a registere
still own and run the theatre.

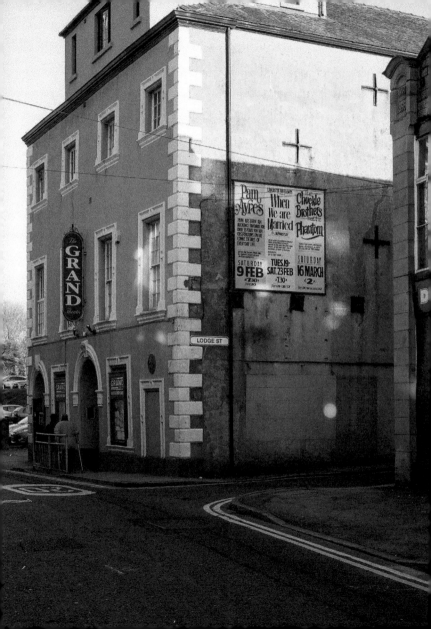

The GRAND Theatre

LODGE ST

GRAND
RESTAURANT

Lancaster Footlights
Pam Ayres
PAM HAS BEEN AN AUDIENCE FAVOURITE FOR OVER 15 YEARS FOR HER OBSERVATIONS ON THE COMIC SIDE OF EVERYDAY LIFE

When We are Married
J.B. PRIESTLEY

The Chuckle Brothers meet the Phantom

SATURDAY
9 FEB
£7.30

TUES.19.
SAT. 23 FEB
£7.30

FRIDAY
16 MARCH
£2

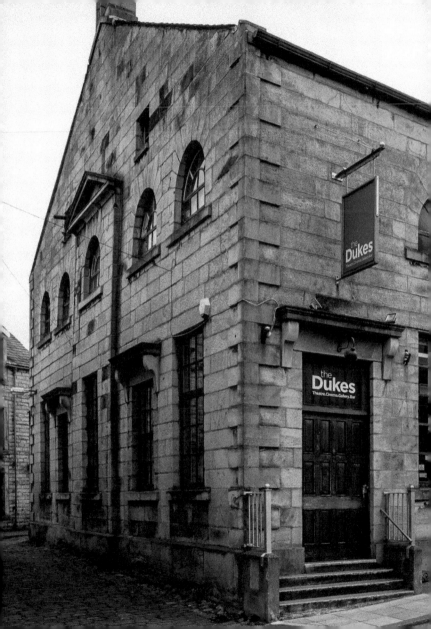

18. DUKES THEATRE

The Dukes (originally called the Duke's Playhouse) opened in 1971. The main building is converted from the former St Anne's church (consecrated in 1796, closed in 1957) and an extension houses a second theatre space. The Dukes is also an important independent cinema and has a welcoming bar/café. (This, or the Golden Lion next door, are the last refreshment opportunities on the walk route before the climb up to Williamson Park.)

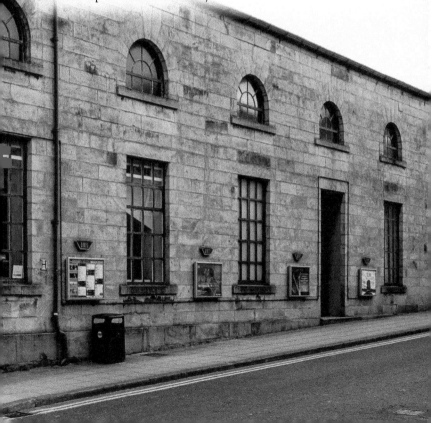

19. GOLDEN LION

In this pub they'll tell you that, when the Pendle Witches and other condemned prisoners made their final journey up the hill to Golgotha, they were allowed a last drink here. The present building isn't the same one, being a mere 200 years old. The exterior has changed only cosmetically in the last fifty years.

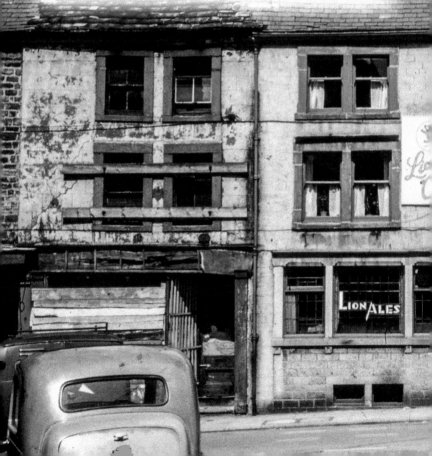

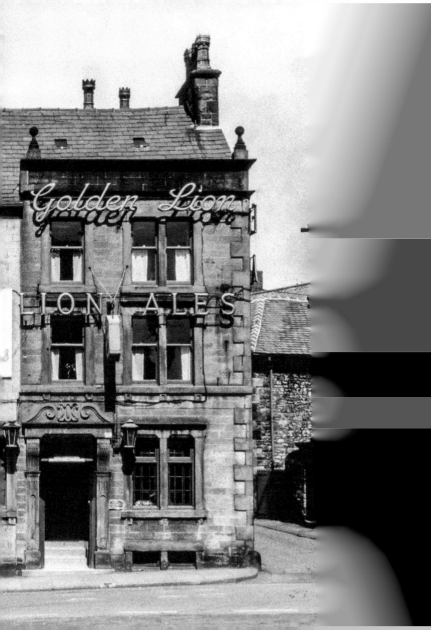

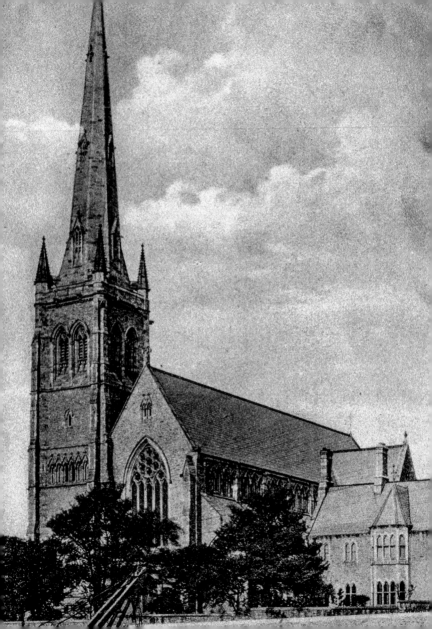

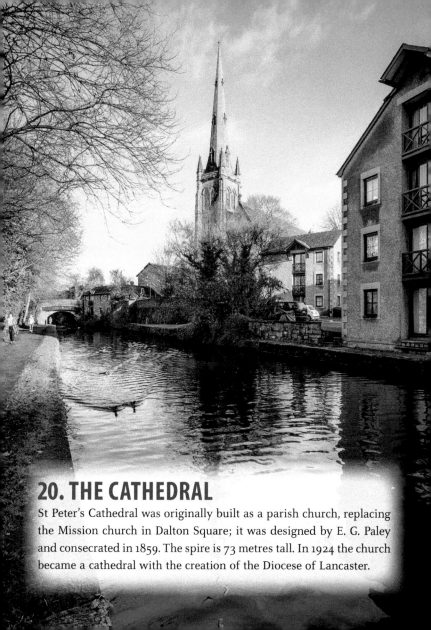

20. THE CATHEDRAL

St Peter's Cathedral was originally built as a parish church, replacing the Mission church in Dalton Square; it was designed by E. G. Paley and consecrated in 1859. The spire is 73 metres tall. In 1924 the church became a cathedral with the creation of the Diocese of Lancaster.

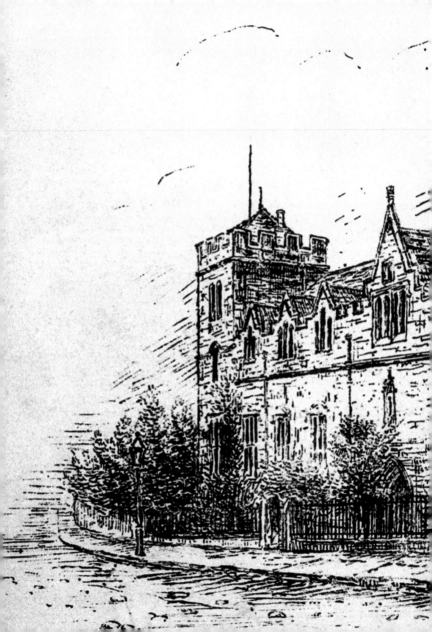

21. LANCASTER ROYAL GRAMMAR SCHOOL

The school moved from Castle Hill to East Road in 1852, gaining the title 'Royal' in the same year. The original building was designed by Sharpe & Paley. The school later expanded – first onto the opposite side of East Road and then further up the hill, absorbing the site of the former Lancaster Union Workhouse. LRGS now has around 1,000 students, of whom around 200 are boarders.

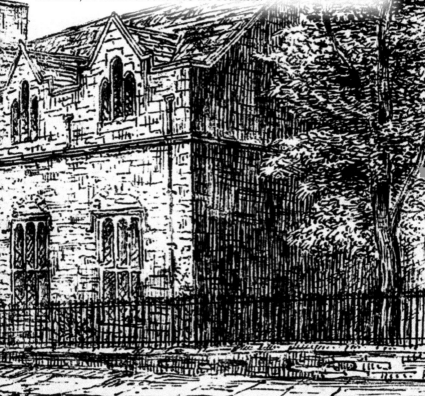

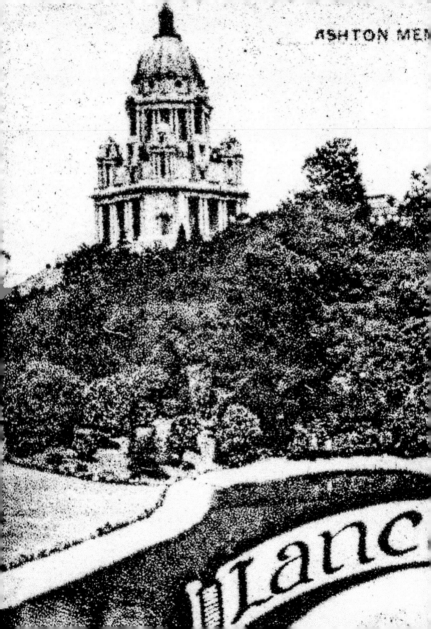

ASHTON MEM

Lanc

22. WILLIAMSON PARK

Williamson Park was created from a cluster of disused quarries around 1879–81 by the first James Williamson, with further additions by his son, who became Lord Ashton. The park included an observatory and bandstand as well as a tropical Palm House, now the Butterfly House – but of course its centrepiece is the Ashton Memorial. For twenty-five years the park and memorial have been used by the Dukes Theatre every summer as the setting for popular and highly acclaimed outdoor productions.

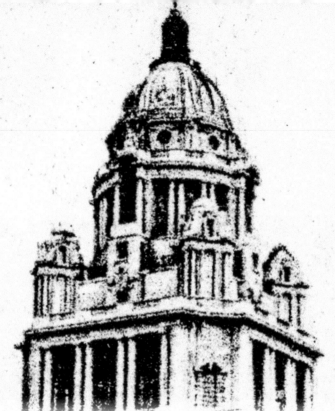

23. THE ASHTON MEMORIAL

Dedicated to Lord Ashton's second wife, Jessie, the memorial was built between 1906 and 1909 to the design of Sir John Belcher and it is Grade I listed. Damaged by fire in 1962, the memorial was in danger of decay, but eventually funds were found to restore it between 1985 and 1987. It has become a popular tourist attraction and wedding venue, and hosts occasional exhibitions and concerts. As it happens, the first show held here after reopening was also my first photographic exhibition.

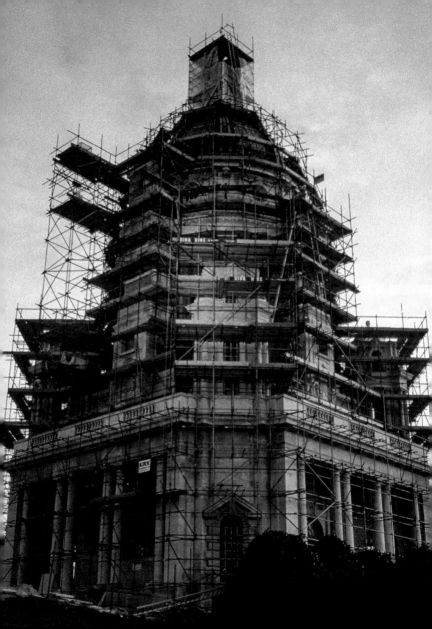

24. GOLGOTHA VILLAGE

Another undated photograph, but the electric tram indicates it can't be earlier than 1903. The name Golgotha, with its Biblical associations, is a slightly macabre reminder that executions took place near this spot – most famously those of the Pendle Witches. The name may also be linked to the presence of an old Quaker cemetery (out of the picture to the right). Some think the site was previously used to bury victims of the Black Death.

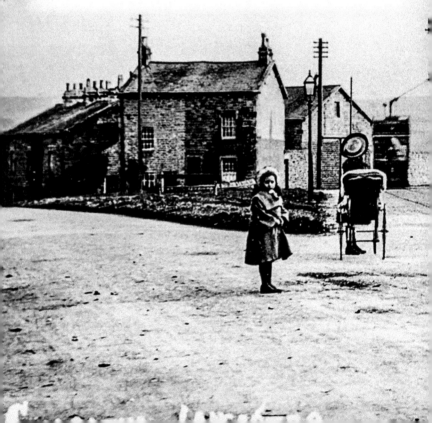

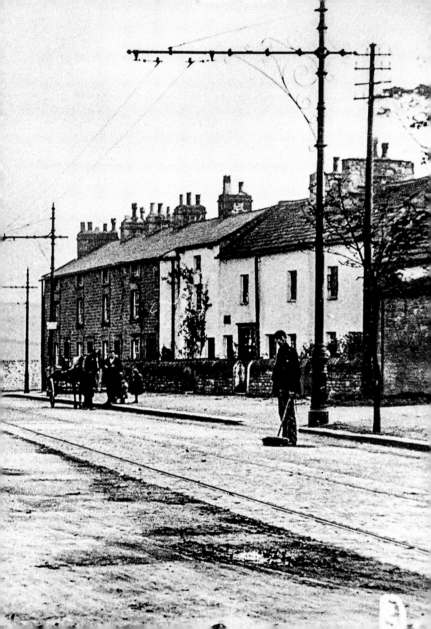

25. SPRINGFIELD BARRACKS

The 1st Royal Lancashire Militia (the Duke of Lancaster's Own) assembles for a photograph outside Springfield Barracks. The building was completed in 1854 and remained in military use until the larger Bowerham Barracks opened in 1881. It was then acquired by Storey Bros to provide office space for the White Cross Mills, directly behind. When the mills closed in 1982, the barracks building and most of the others on the site were gradually converted to office and light industrial use.

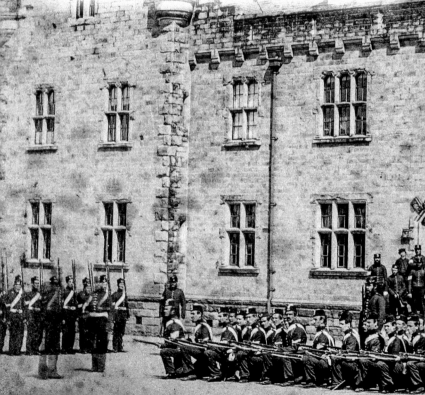

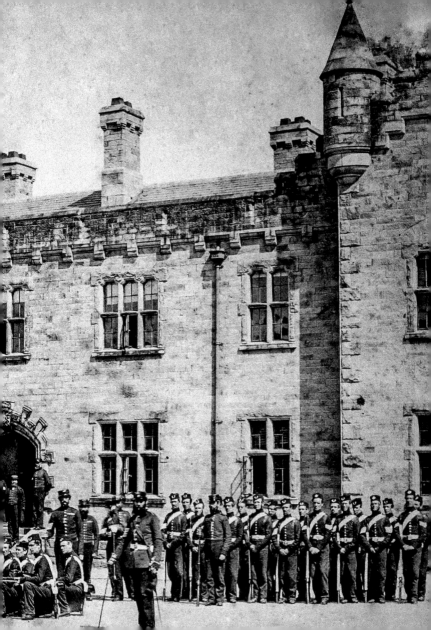

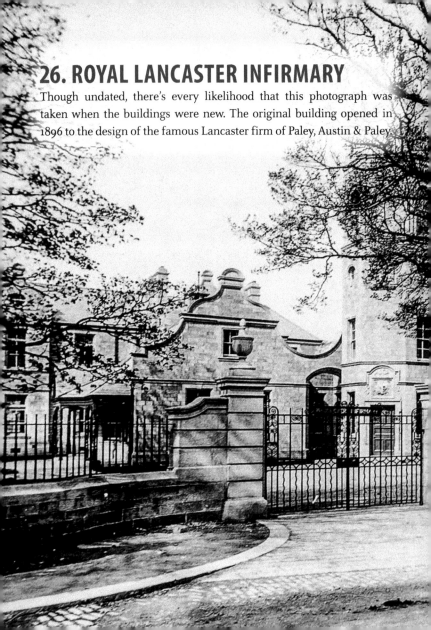

26. ROYAL LANCASTER INFIRMARY

Though undated, there's every likelihood that this photograph was taken when the buildings were new. The original building opened in 1896 to the design of the famous Lancaster firm of Paley, Austin & Paley.

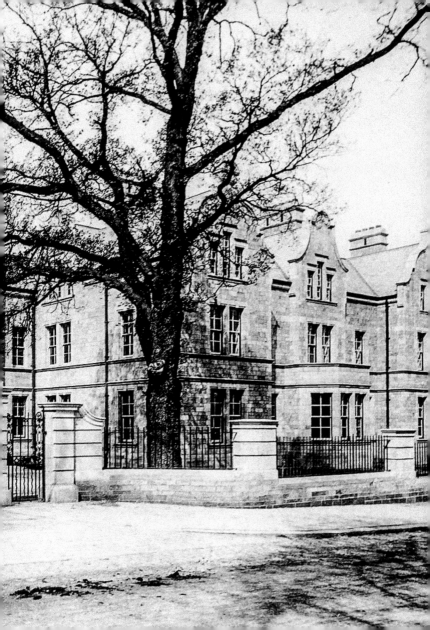

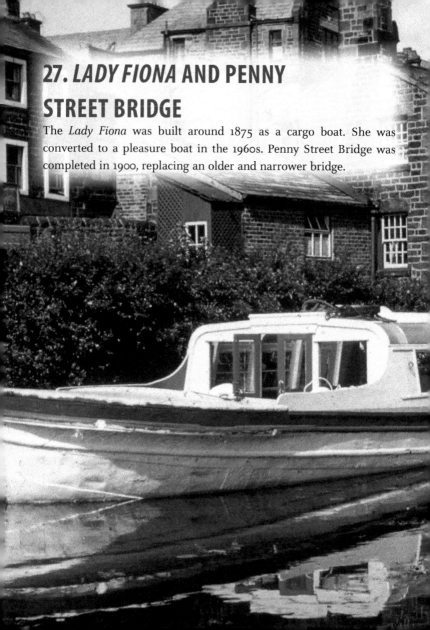

27. *LADY FIONA* AND PENNY STREET BRIDGE

The *Lady Fiona* was built around 1875 as a cargo boat. She was converted to a pleasure boat in the 1960s. Penny Street Bridge was completed in 1900, replacing an older and narrower bridge.

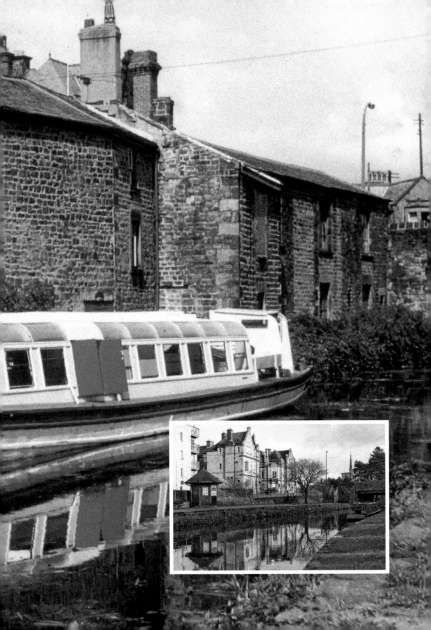

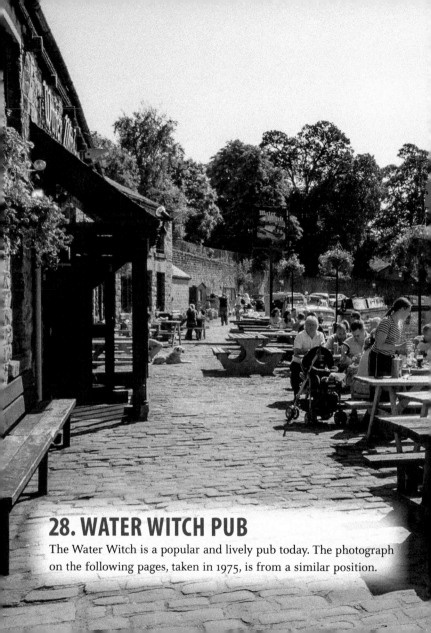

28. WATER WITCH PUB

The Water Witch is a popular and lively pub today. The photograph
on the following pages, taken in 1975, is from a similar position.

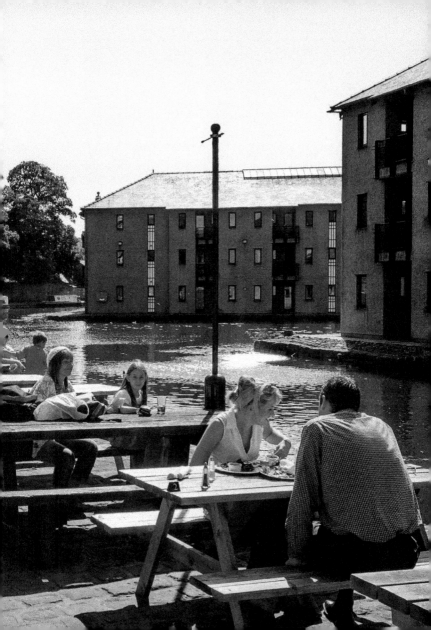

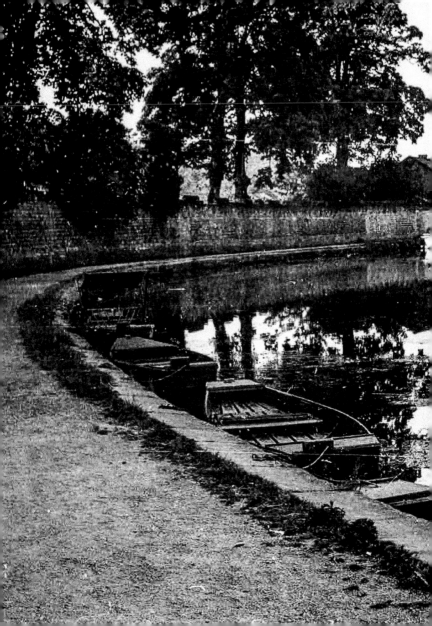

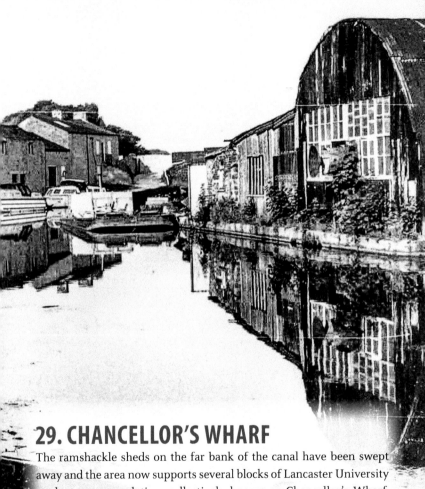

29. CHANCELLOR'S WHARF

The ramshackle sheds on the far bank of the canal have been swept away and the area now supports several blocks of Lancaster University student accommodation, collectively known as Chancellor's Wharf. The punts visible in the foreground could be hired from the Stables – now the Water Witch (see previous page).

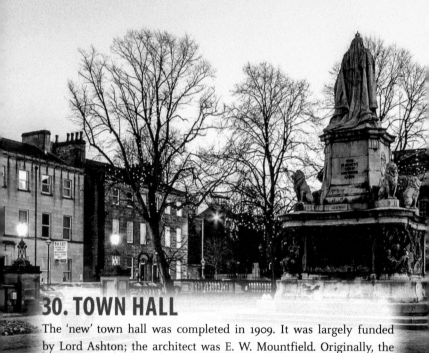

30. TOWN HALL

The 'new' town hall was completed in 1909. It was largely funded by Lord Ashton; the architect was E. W. Mountfield. Originally, the building incorporated the police station and magistrates' court; the fire station was in an adjoining building opening onto George Street. The Victoria monument at the centre of Dalton Square was unveiled in 1906. Its plinth is decorated with reliefs depicting eminent Victorians, including Lord Ashton.

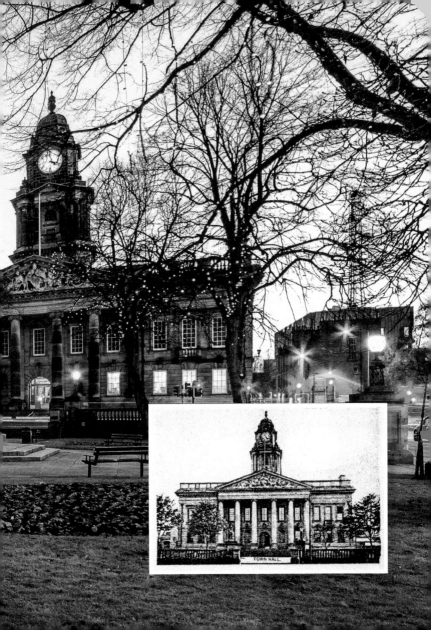

TOWN HALL.

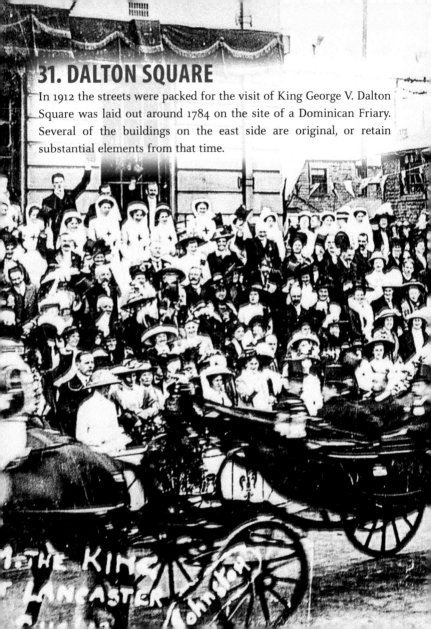

31. DALTON SQUARE

In 1912 the streets were packed for the visit of King George V. Dalton Square was laid out around 1784 on the site of a Dominican Friary. Several of the buildings on the east side are original, or retain substantial elements from that time.

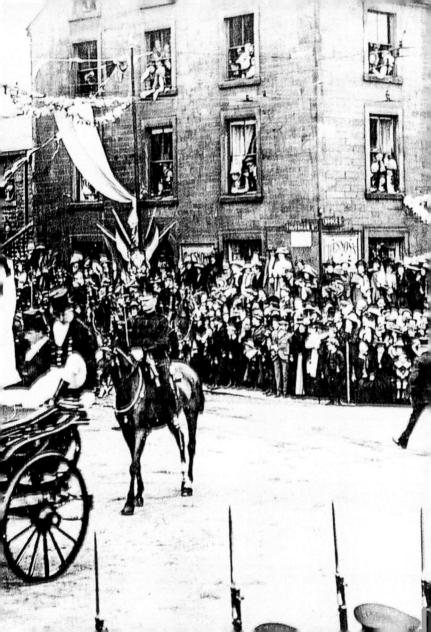

32. THE BOROUGH

The building at the north-east corner of Dalton Square dates from 1824, with a frontage remodelled in Victorian times. Once the mayor's house, it was a working men's club for much of the twentieth century, and is now a popular pub – The Borough.

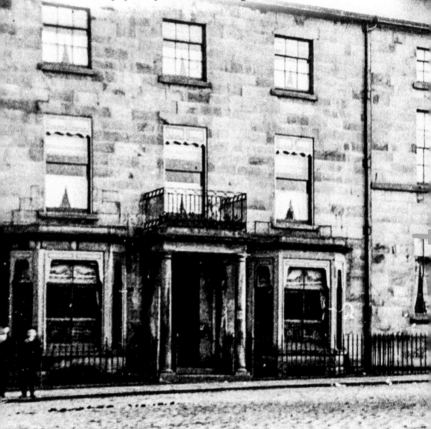

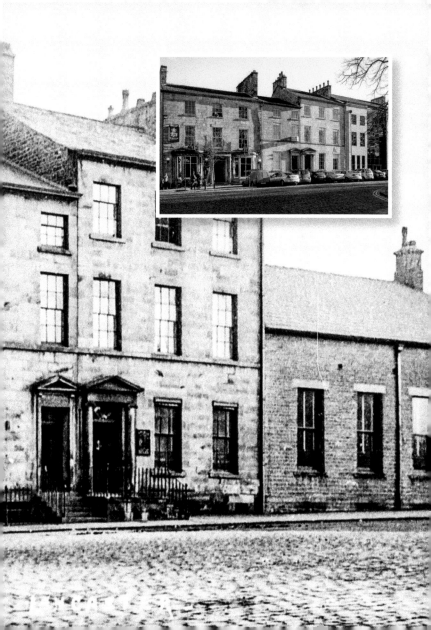

LANCASTER

33. THE COUNTY CINEMA

This building has a varied history, beginning as a Catholic Mission church consecrated in 1799. It later became a variety theatre and opera house and then a cinema. Today it houses city council offices. In 1935, the house became the scene of a notorious murder. It was the home and surgery of Dr Buck Ruxton, who killed his wife in a jealous rage, and then killed the maid who had witnessed the first murder. He drove to Scotland to dispose of the bodies, but on the return knocked a cyclist from his bike in Kendal. The cyclist noted the car's registration and this was a vital piece of evidence in Ruxton's conviction. He was hanged in Manchester in 1936.

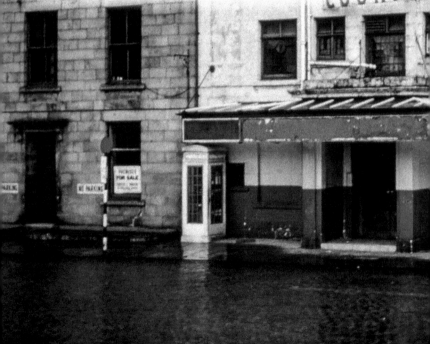

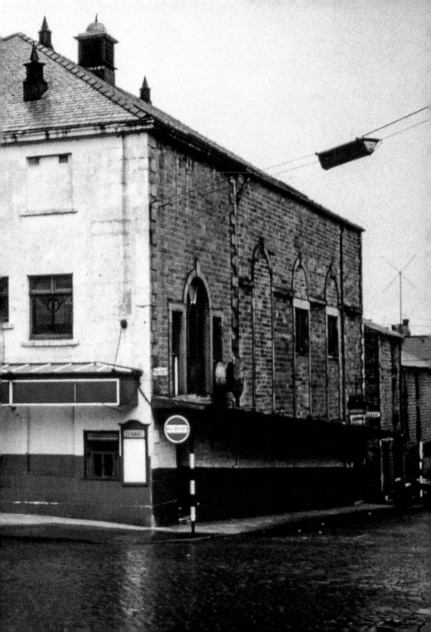

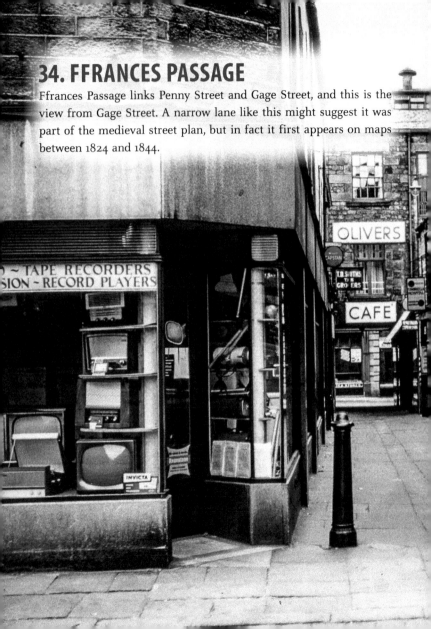

34. FFRANCES PASSAGE

Ffrances Passage links Penny Street and Gage Street, and this is the
view from Gage Street. A narrow lane like this might suggest it was
part of the medieval street plan, but in fact it first appears on maps
between 1824 and 1844.

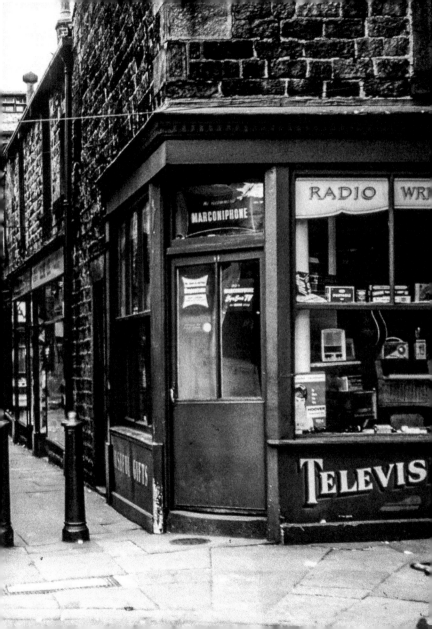

35. HORSESHOE CORNER

Horseshoe Corner is the local name for the meeting of Penny Street, Market Street, Cheapside, and the former St Nicholas Street. Local legend claims that John O'Gaunt's horse shed a shoe as he was leaving Lancaster for the last time. For centuries, a horseshoe has traditionally been embedded in the paving here. At one time, it was renewed every seven years, and a festival was held to mark the occasion.

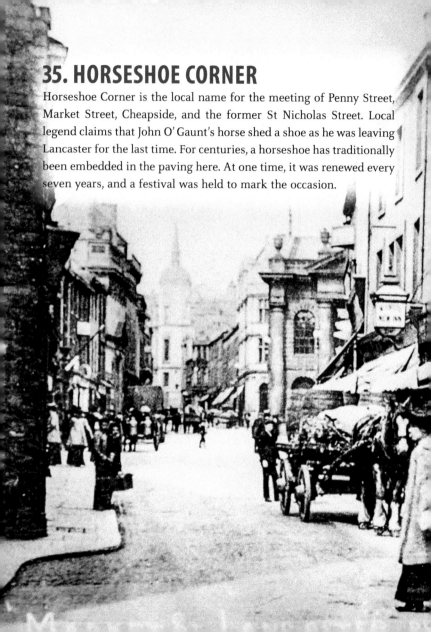

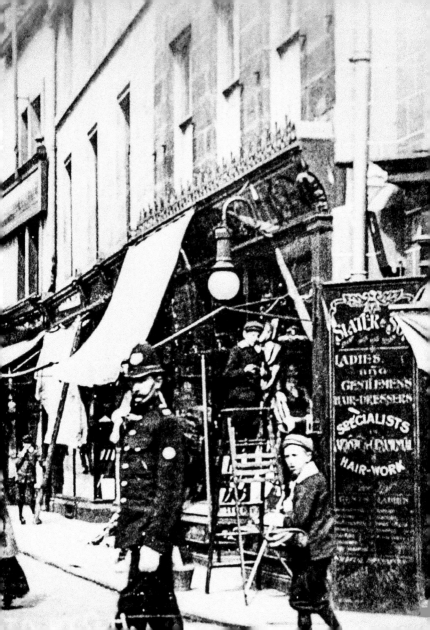

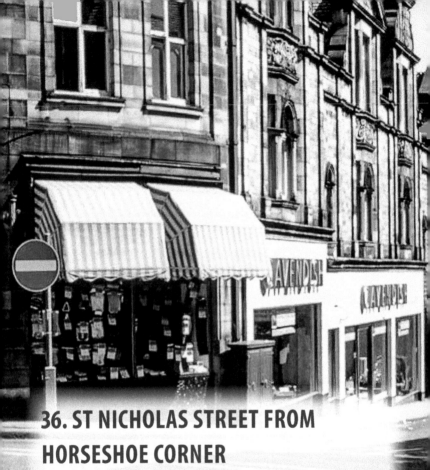

36. ST NICHOLAS STREET FROM HORSESHOE CORNER

This photograph is taken from the same position as the one on the previous page, but looking in the opposite direction. The only building still recognisable is the curved frontage on the left, now occupied by Thomas Cook. The rest were demolished in the early 1970s to make way for the new St Nicholas Arcades – which have themselves been extensively rebuilt since then.

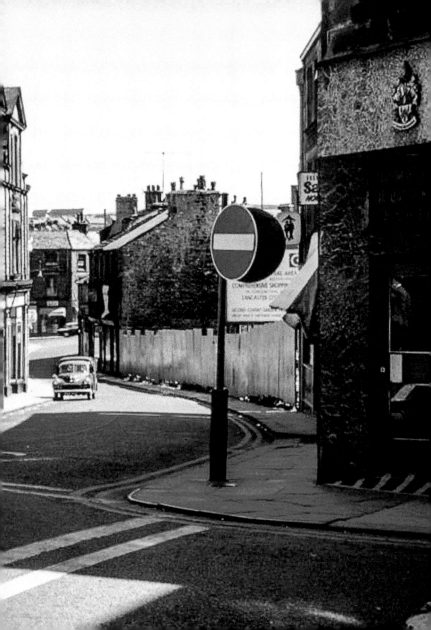

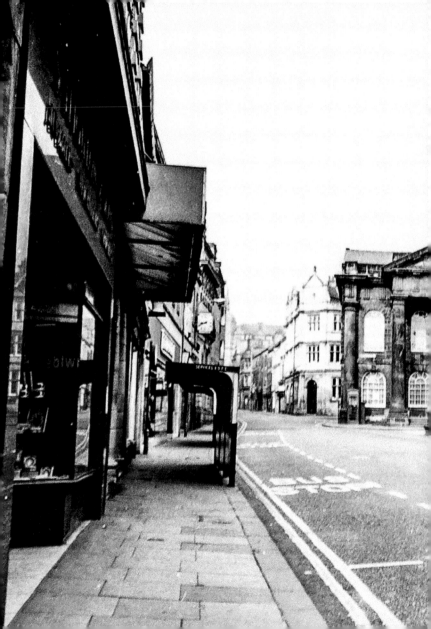

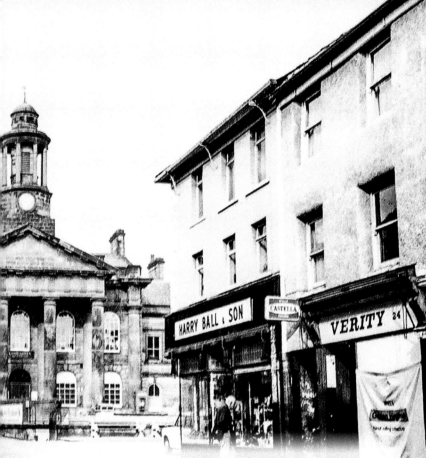

37. MARKET STREET

It's hard to believe now that in 1973 Market Street was fully open to motor traffic and indeed had a couple of bus stops. When proposals for pedestrianisation were first aired, there was considerable resistance, not least from traders who expected it to kill their business. However, the prime retail sites in town today are on traffic-free streets.

38. MARKET SQUARE

Market Square has been the real heart of Lancaster for centuries. The original town hall was built in 1781/82, but it became the City Museum after the opening of the new town hall in Dalton Square. The square has had many uses too, from hosting markets to being a bus station.

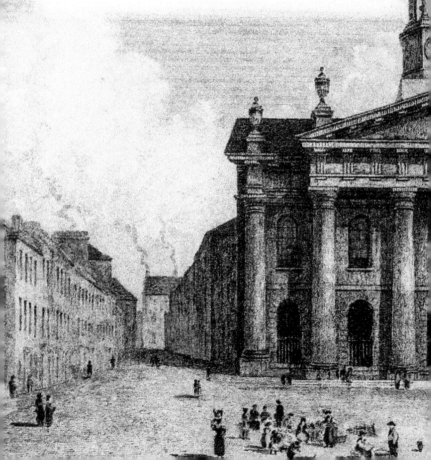

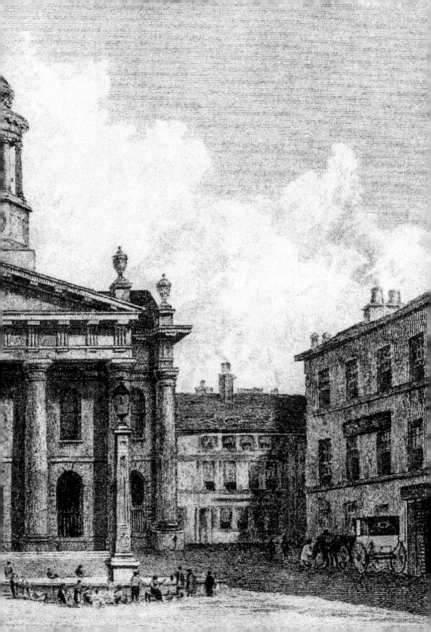

39. SIR SIMON'S ARCADE

Sir Simon's Arcade is apparently so named because the building on the right (now Diggle's) was at one time a pub, the Sir Simon.

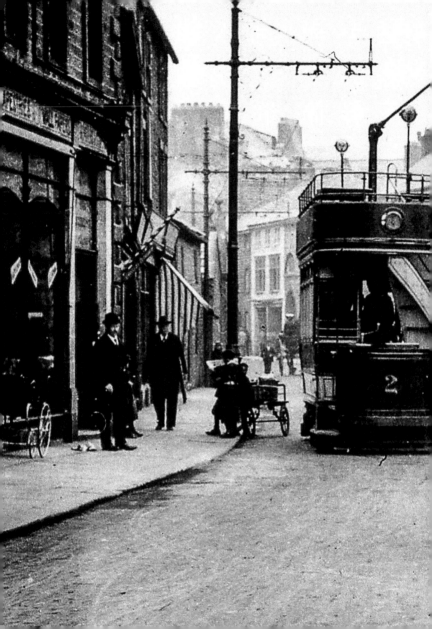

40. KING STREET

The vantage point takes a little working out but the entrance to Common Garden Street – obvious today – can be found by tracing the tram tracks: the man on the bike has just emerged from it, behind the ladies in the serious hats. Lancaster had horse-drawn trams in the 1890s and an electric system began operating in 1903. It was withdrawn in 1930.

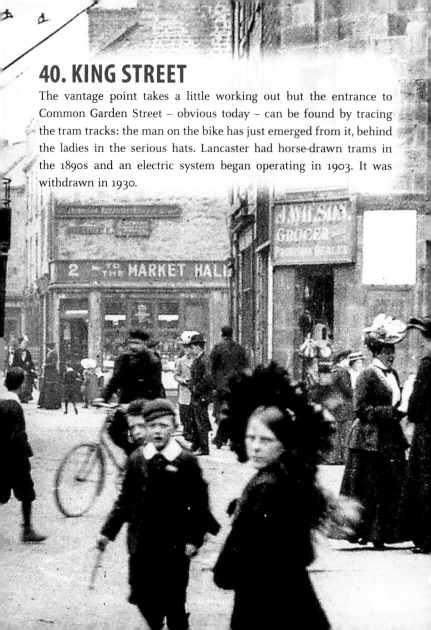

41. PENNY'S ALMHOUSES, KING STREET

Penny's Almshouses (also known as Penny's Hospital) are named after William Penny, a former mayor of Lancaster, who also gives his name to Penny Street. They were built in 1720 to provide accommodation for 'twelve poor men' of the city, and are still lived in today. The chapel, in the centre, is often open and visitors can take a look inside.

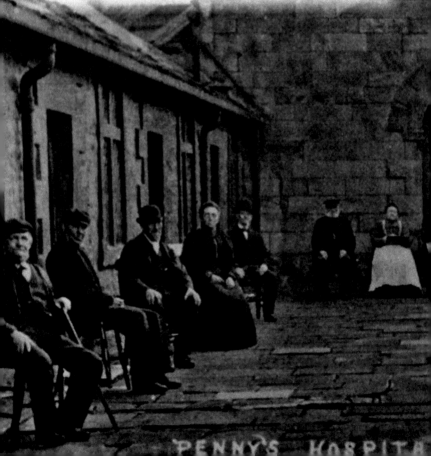

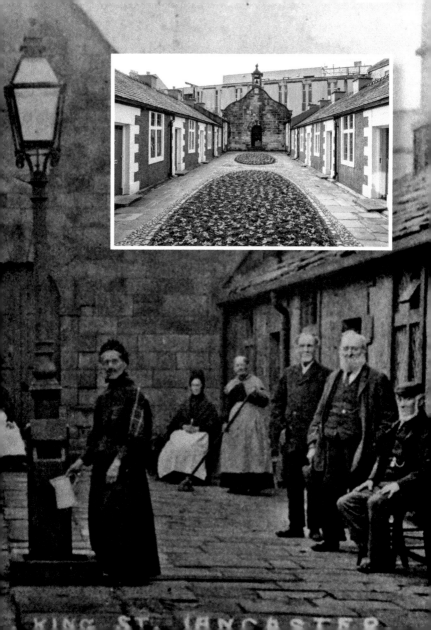

KING ST. LANCASTER

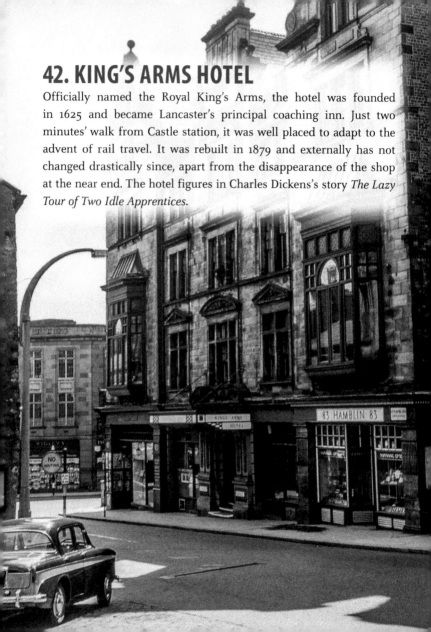

42. KING'S ARMS HOTEL

Officially named the Royal King's Arms, the hotel was founded in 1625 and became Lancaster's principal coaching inn. Just two minutes' walk from Castle station, it was well placed to adapt to the advent of rail travel. It was rebuilt in 1879 and externally has not changed drastically since, apart from the disappearance of the shop at the near end. The hotel figures in Charles Dickens's story *The Lazy Tour of Two Idle Apprentices*.

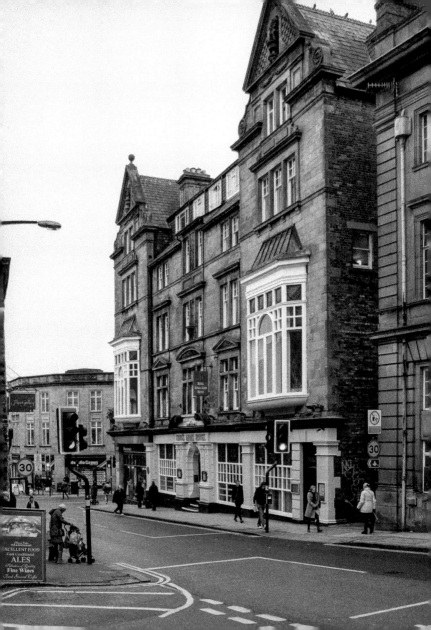

43. THE MUSIC ROOM

The Music Room has a chequered history. It's believed to have been built around 1730, probably at the bottom of someone's garden; however, it became 'orphaned' and hemmed in by later buildings. In 1972, it was neglected and decaying. Fortunately, the Landmark Trust stepped in, buying and demolishing the adjacent properties. The ground floor is now a coffee shop and the upper floors are let out by the Trust as self-catering accommodation.

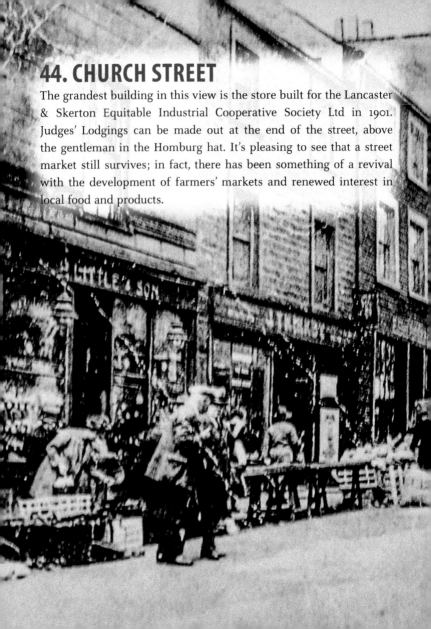

44. CHURCH STREET

The grandest building in this view is the store built for the Lancaster & Skerton Equitable Industrial Cooperative Society Ltd in 1901. Judges' Lodgings can be made out at the end of the street, above the gentleman in the Homburg hat. It's pleasing to see that a street market still survives; in fact, there has been something of a revival with the development of farmers' markets and renewed interest in local food and products.

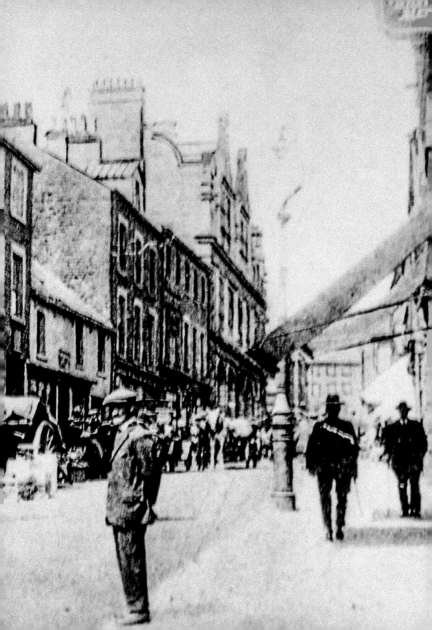

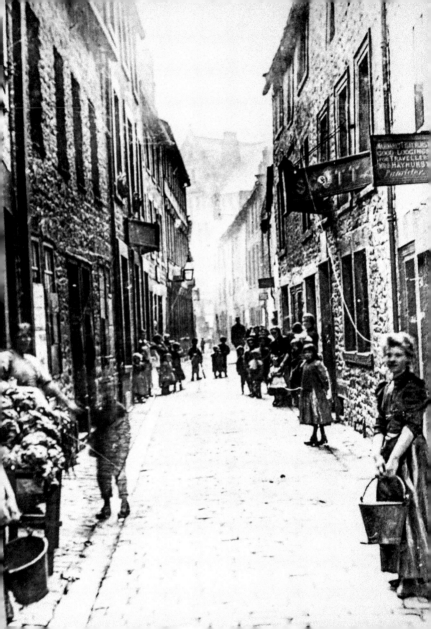

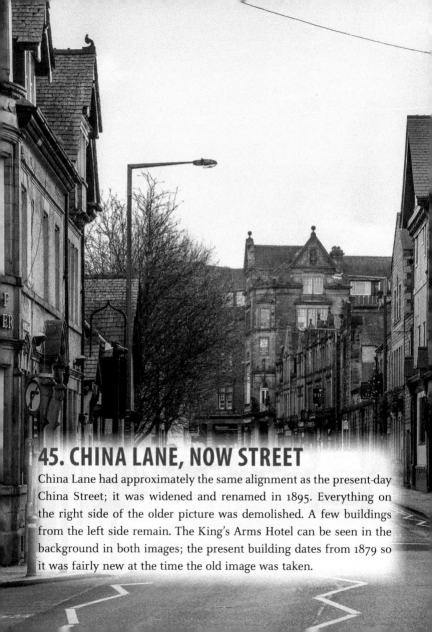

45. CHINA LANE, NOW STREET

China Lane had approximately the same alignment as the present-day China Street; it was widened and renamed in 1895. Everything on the right side of the older picture was demolished. A few buildings from the left side remain. The King's Arms Hotel can be seen in the background in both images; the present building dates from 1879 so it was fairly new at the time the old image was taken.

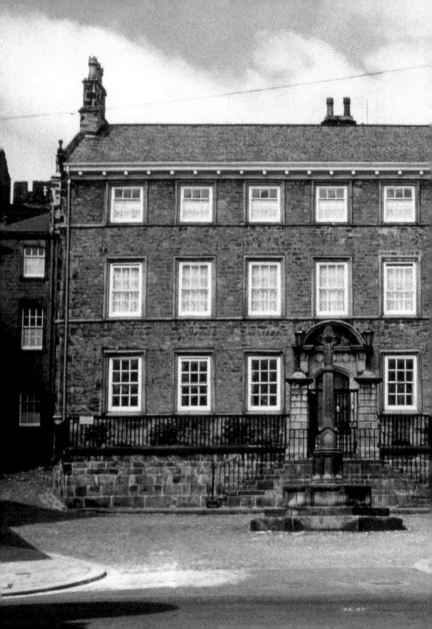

46. JUDGES' LODGINGS

This Grade I listed building is the oldest town house in Lancaster. Most of the structure dates to around 1625. There were several later alterations and the frontage is essentially Georgian. In the seventeenth century it belonged to Thomas Covell, Mayor of Lancaster and Keeper of the Castle. His name attaches to the cross that stands in front. The house was later used as accommodation for judges travelling the county circuit. Today it houses a Gillow furniture collection as well as a Museum of Childhood.

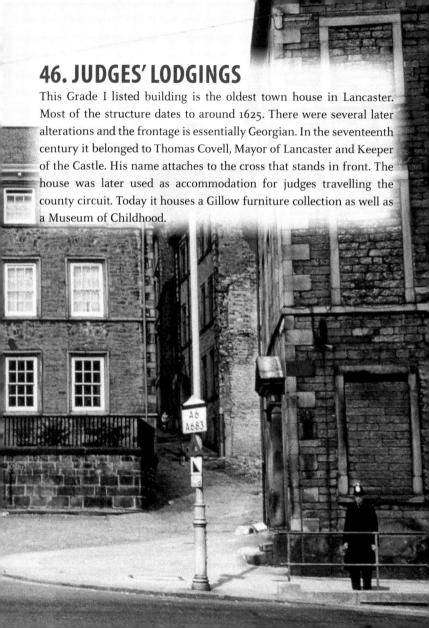

47. THE STOREY INSTITUTE

The Storey Institute was erected in 1887–91 to a design by Paley, Austin & Paley, replacing an earlier mechanics' institute. Its purpose was 'the promotion of art, science, literature, and technical instruction'. Today, under the name Storey Creative Industries Centre – or just 'the Storey' – it is home to several businesses in the creative sector, as well as a café, a restaurant and the visitor information centre.

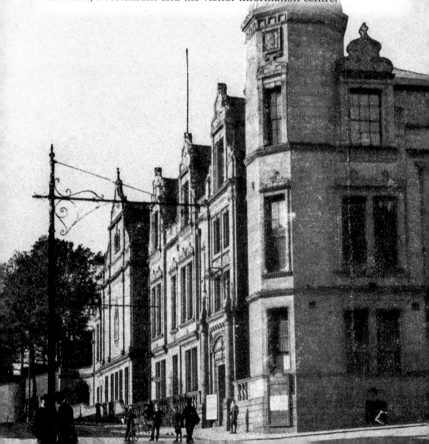